Coffee Table Cartoons

Pud and Beaky

Eleanor Russell Brown

the Peppertree Press
Sarasota, Florida

Other titles by
Eleanor Russell Brown
www.eleanorrussellbrown.com

Copyright © Eleanor Russell Brown, 2015
All rights reserved. Published by the Peppertree Press, LLC. The Peppertree Press and associated logos are trademarks of the Peppertree Press, LLC. No part of this publication may be reproduced, stored in a retrieval system, transmitted in any form or by any means, electronic, mechanical, photocopying, recording or otherwise, without prior written permission of the publisher and author/illustrator. Graphic design by Rebecca Barbier. For information regarding permission, call 941-922-2662 or contact us at our website: www.peppertreepublishing.com or write to: the Peppertree Press, LLC. Attention: Publisher
1269 First Street, Suite 7, Sarasota, Florida 34236
ISBN: 978-1-61493-399-1
Library of Congress Number: 2015916098
Printed November 2015

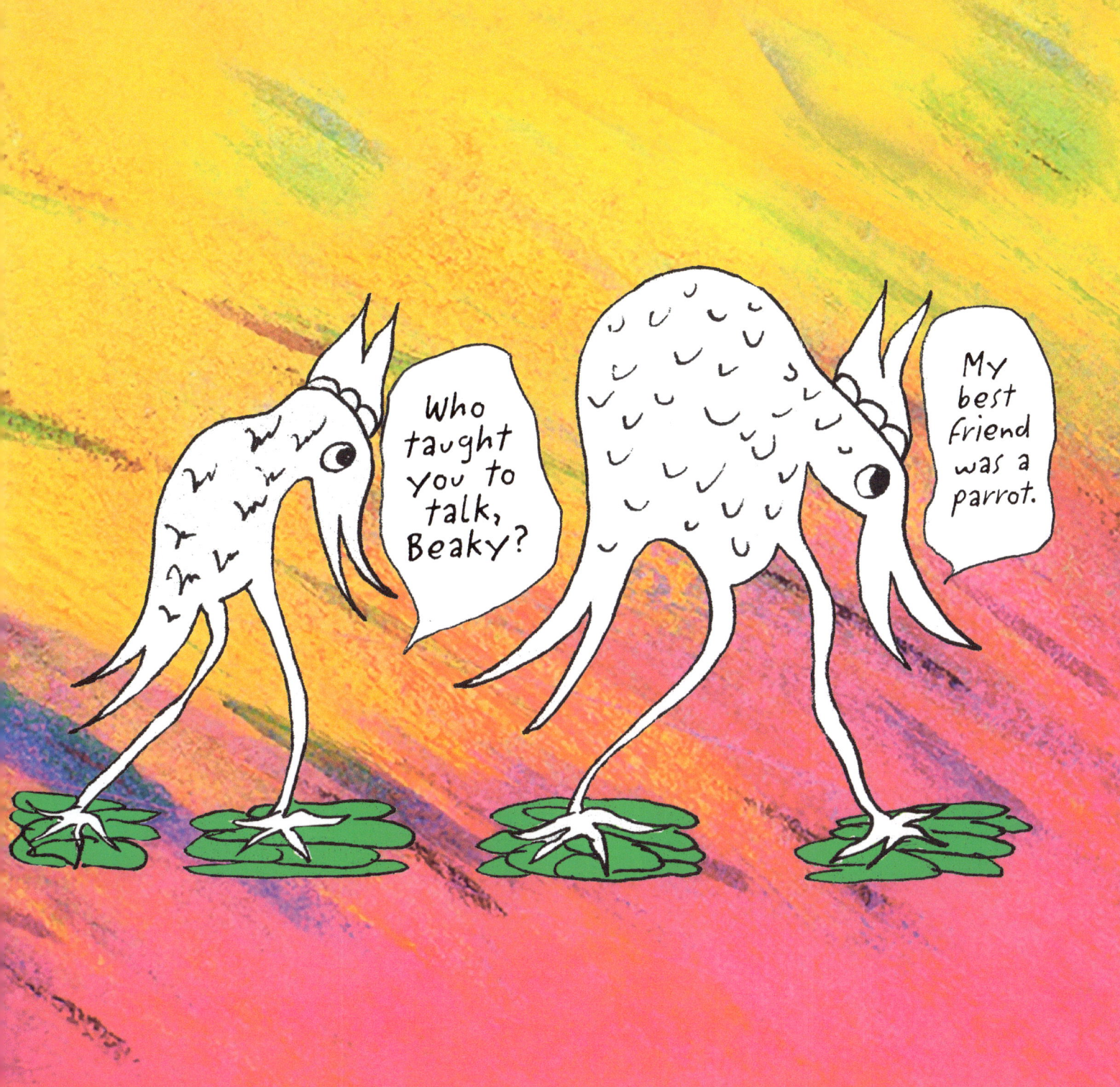

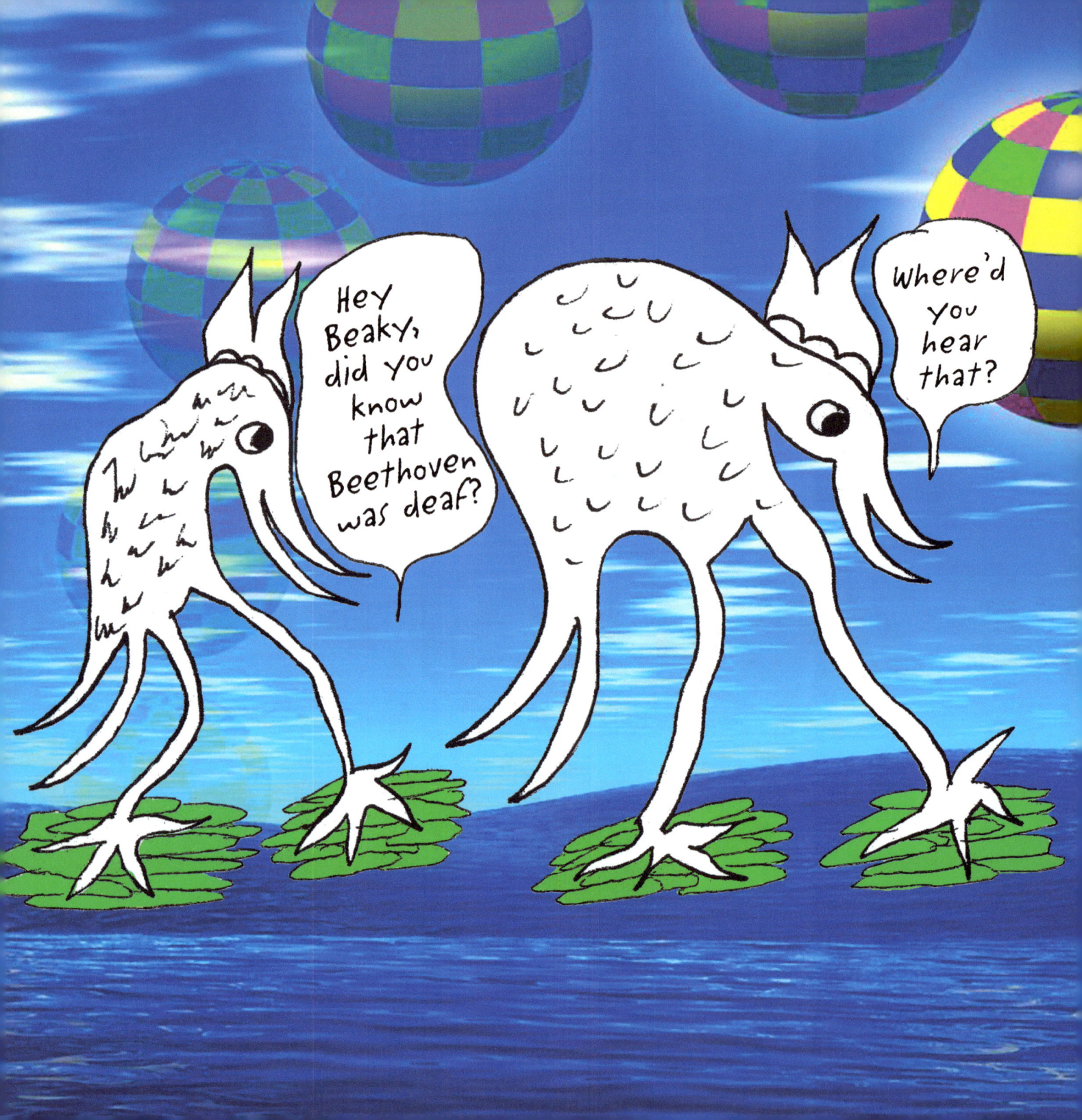

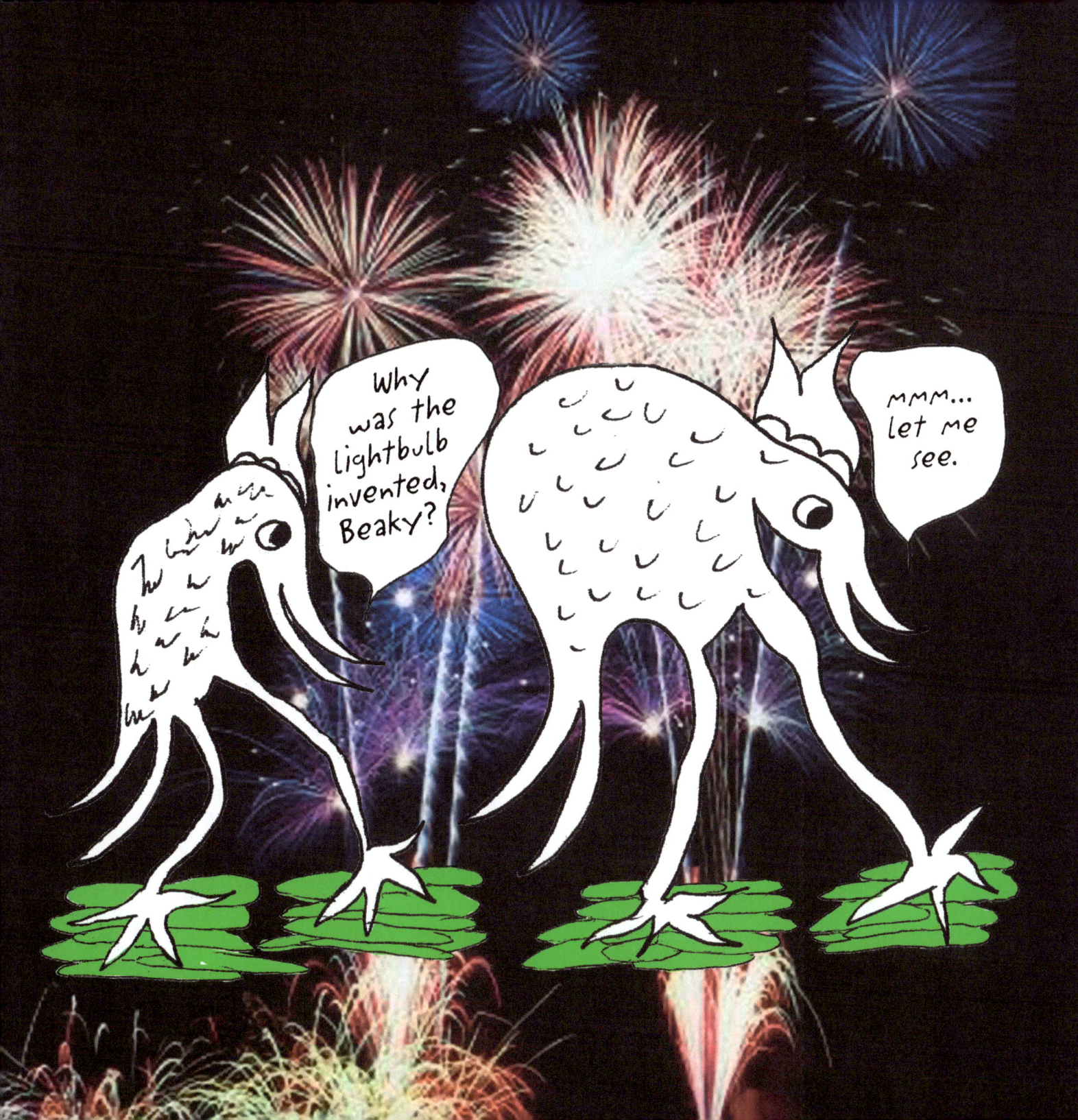

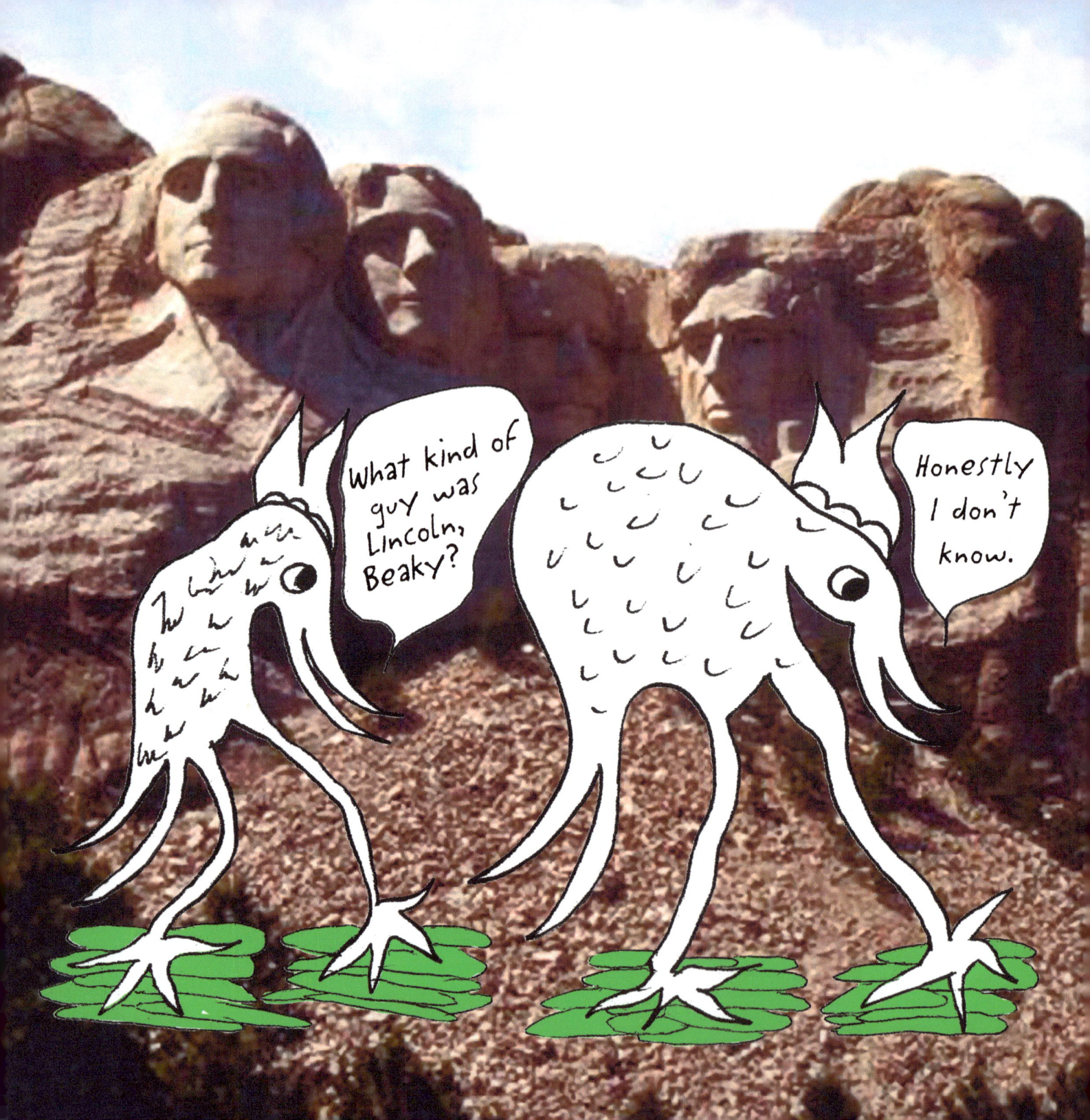

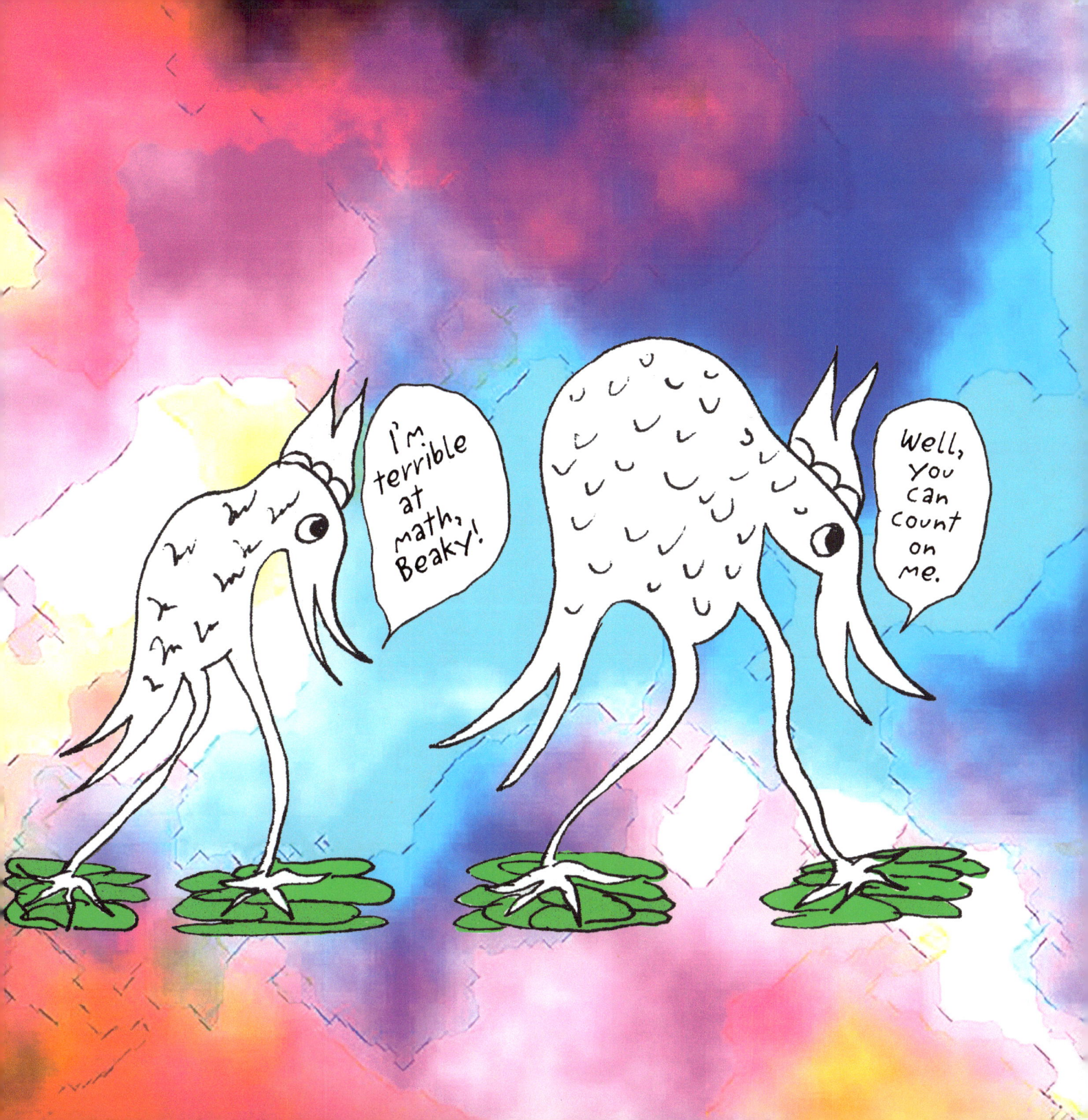

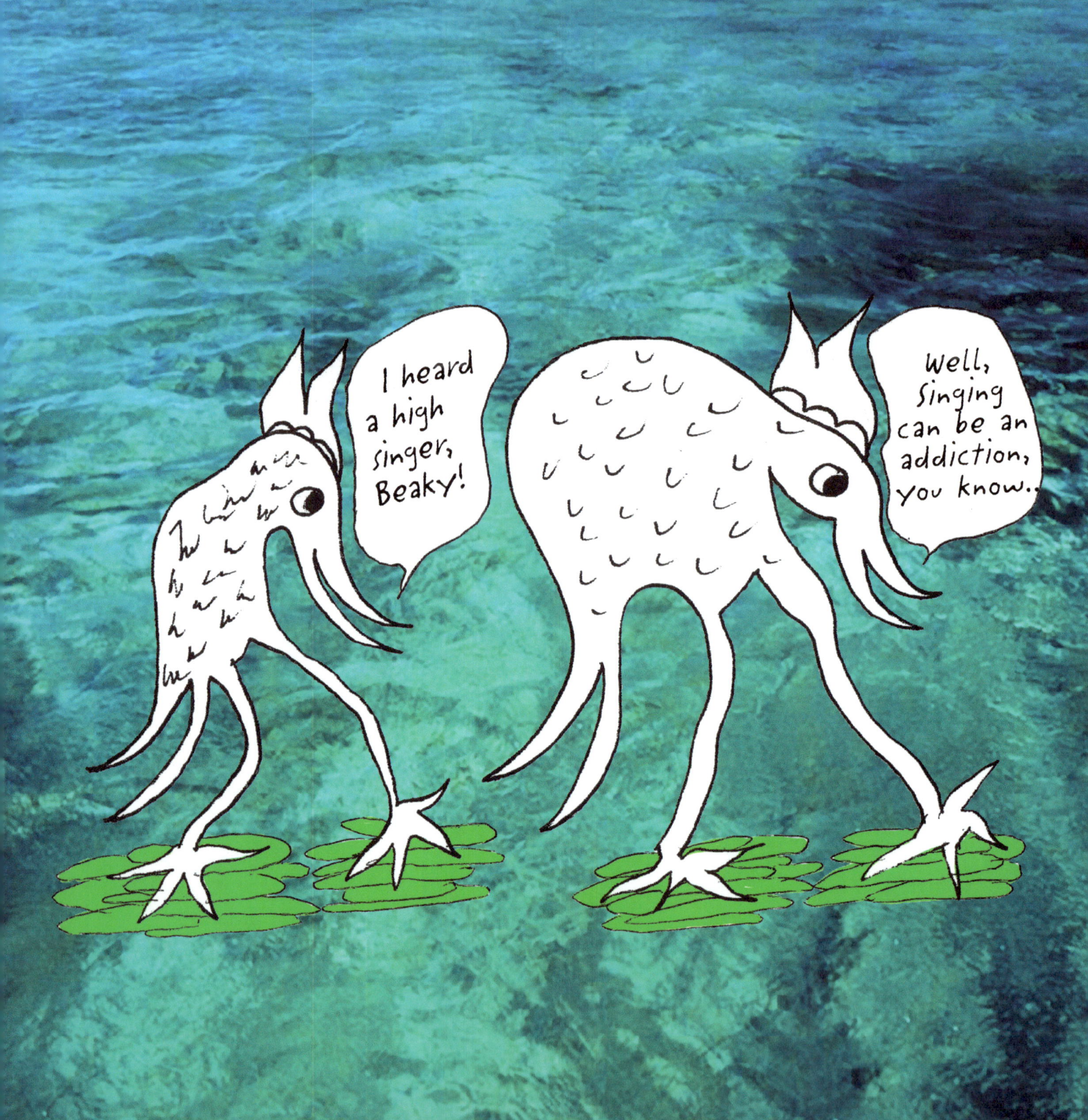

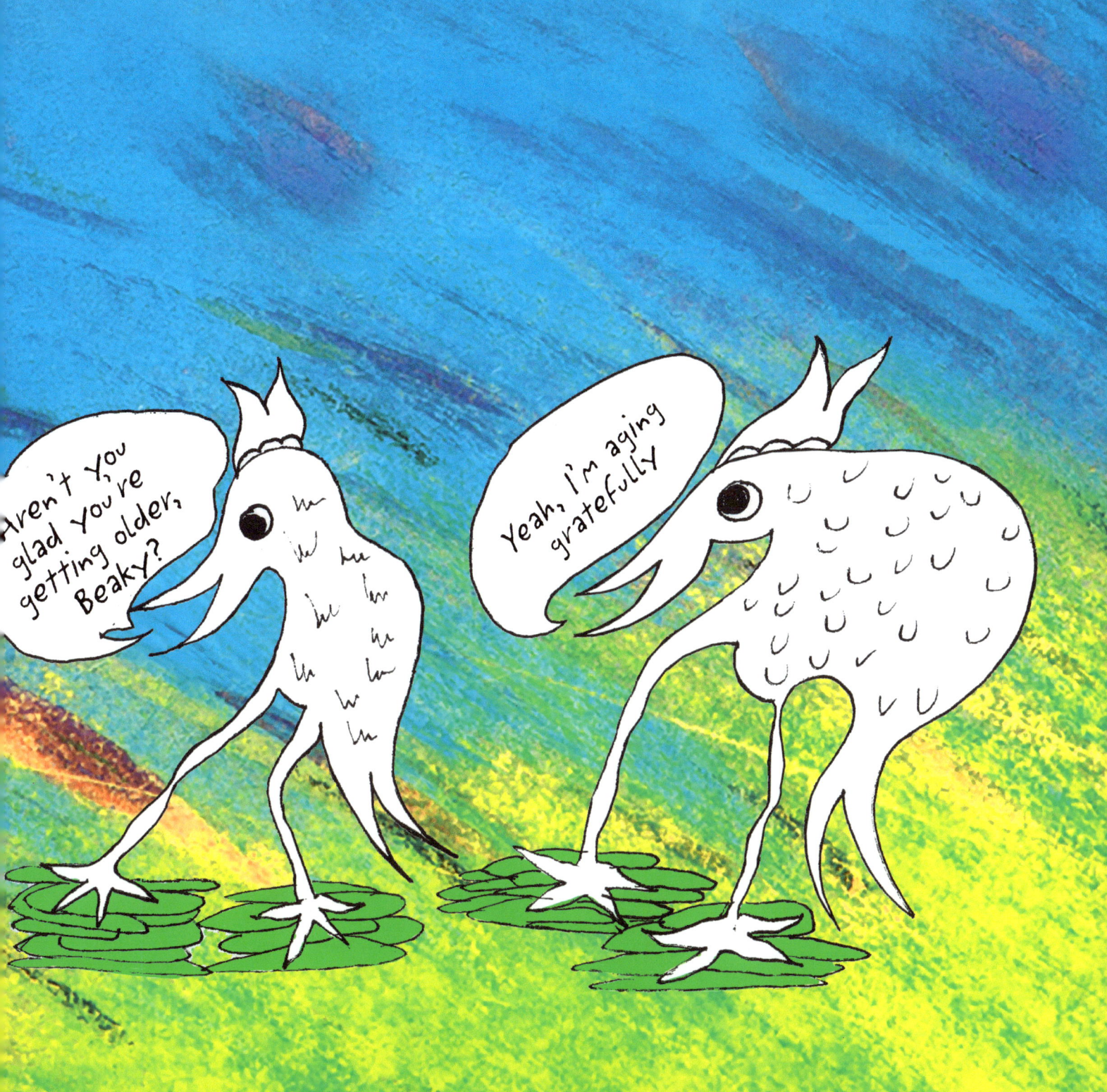

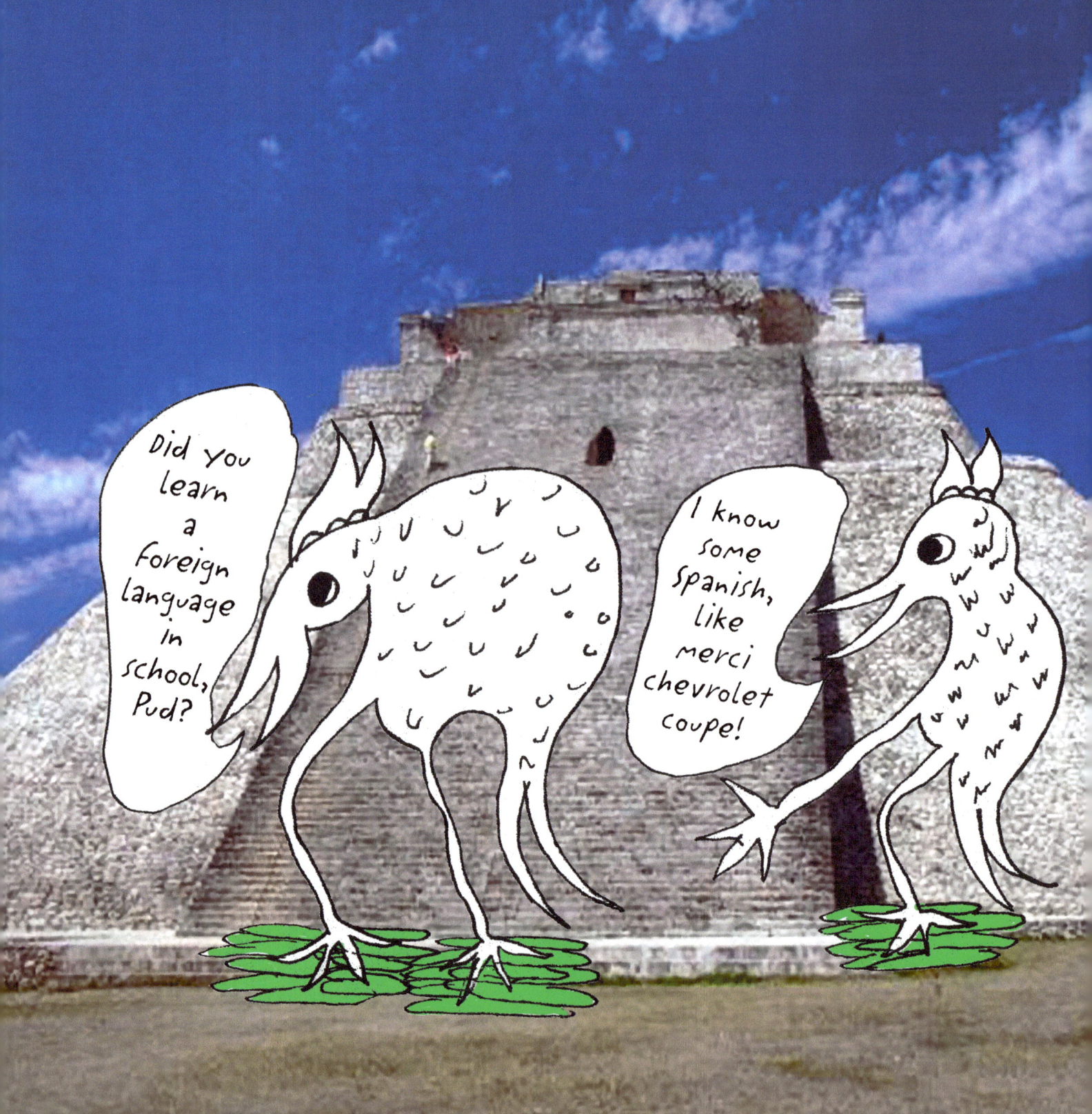

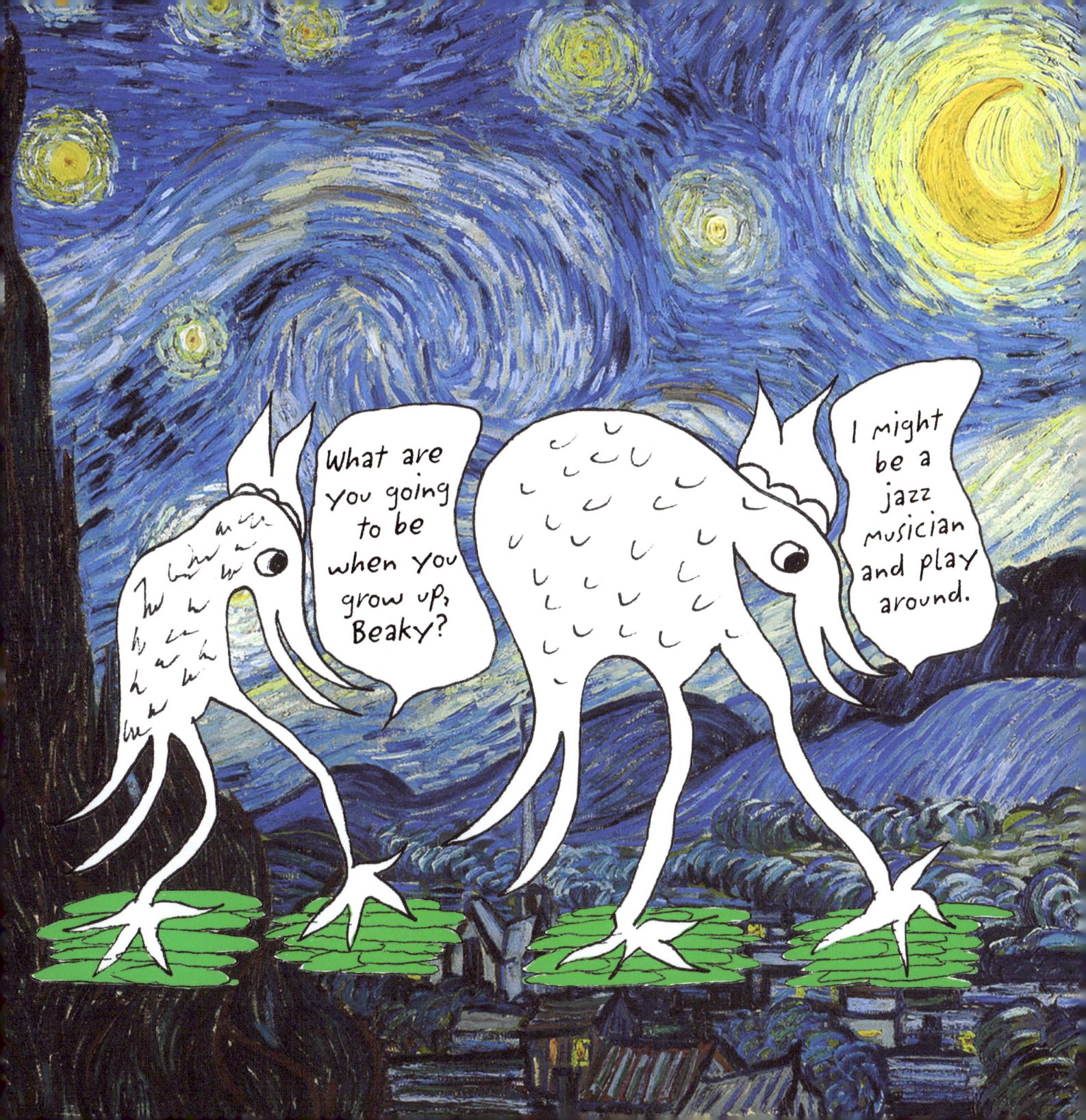

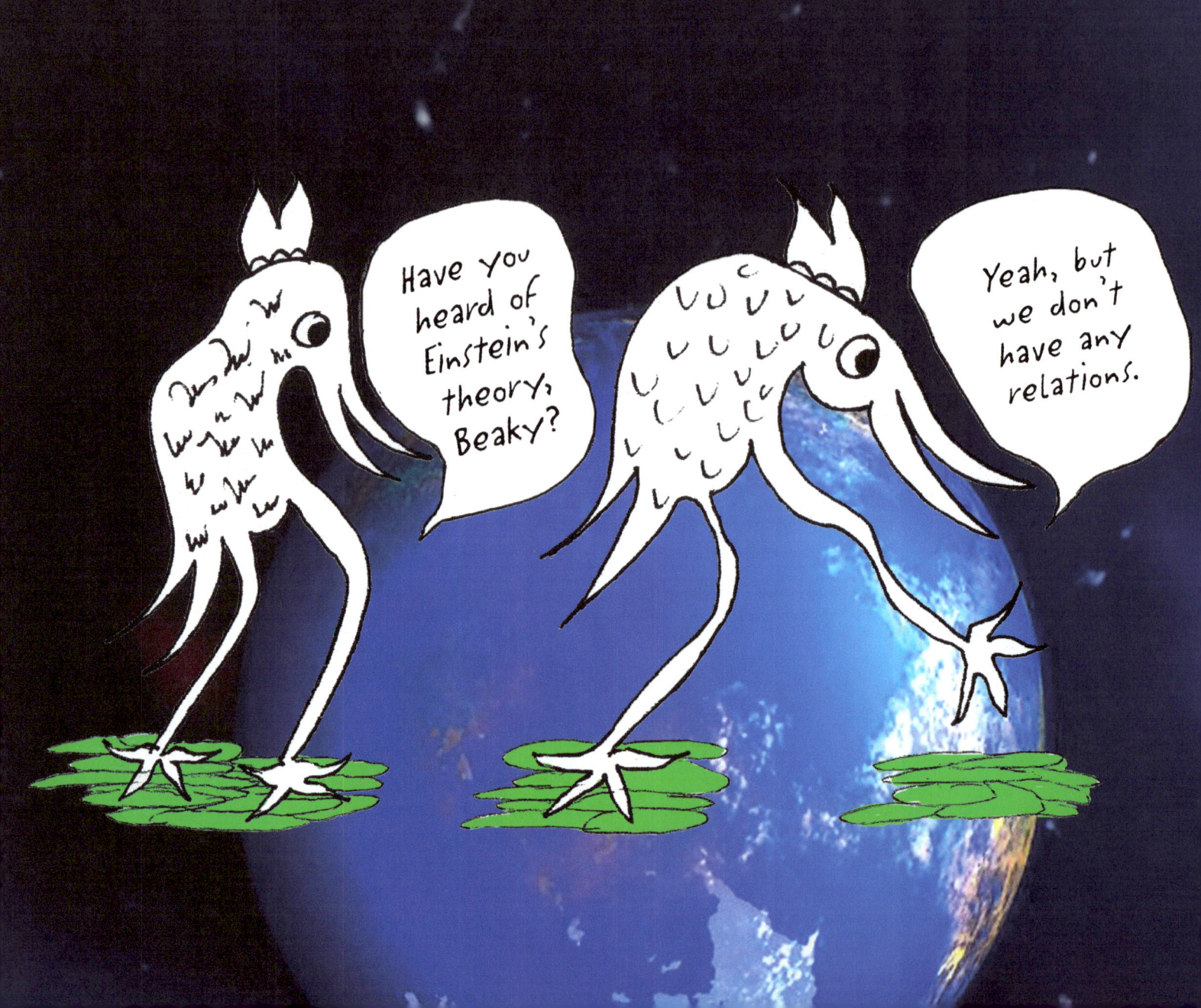

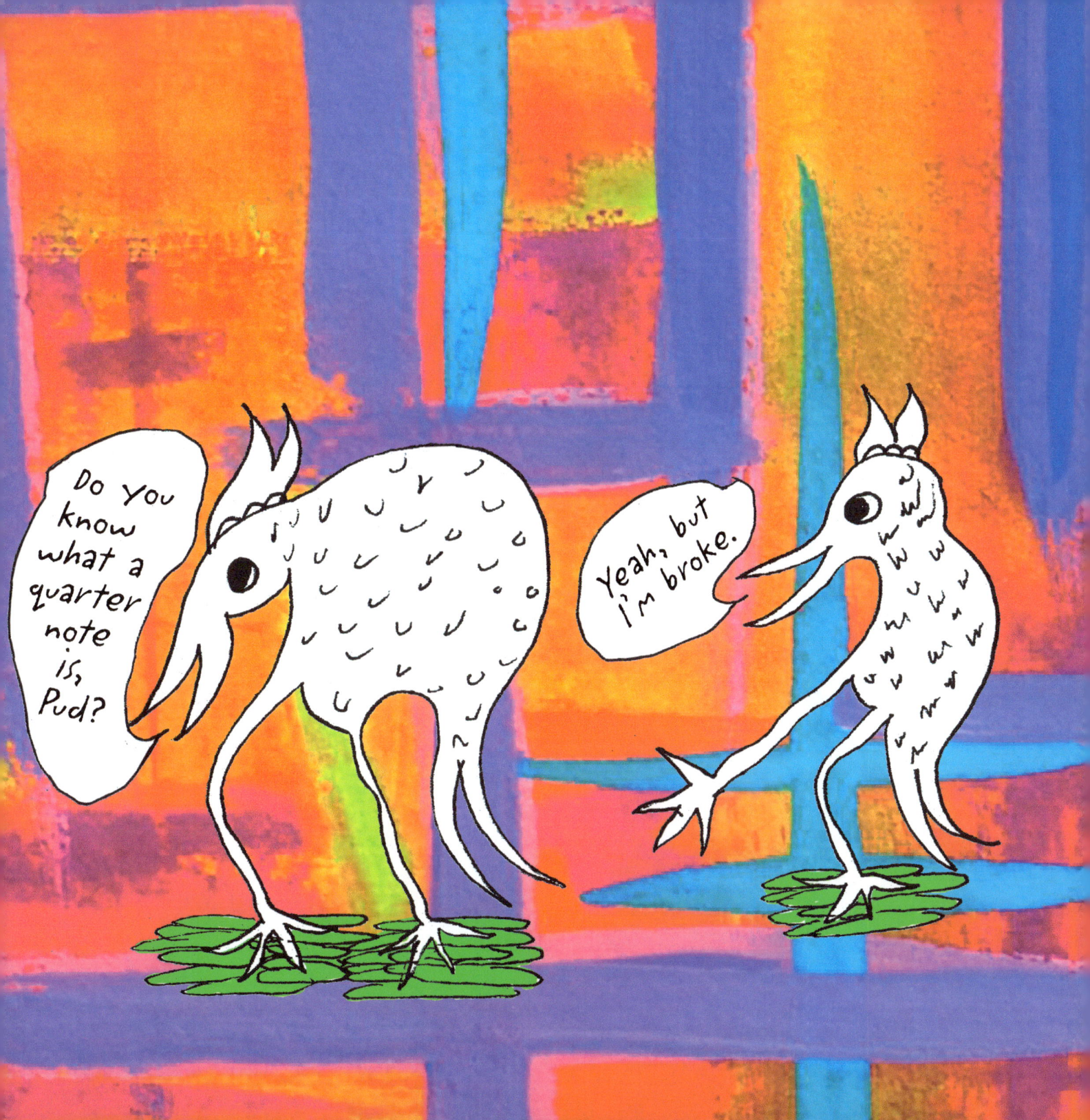

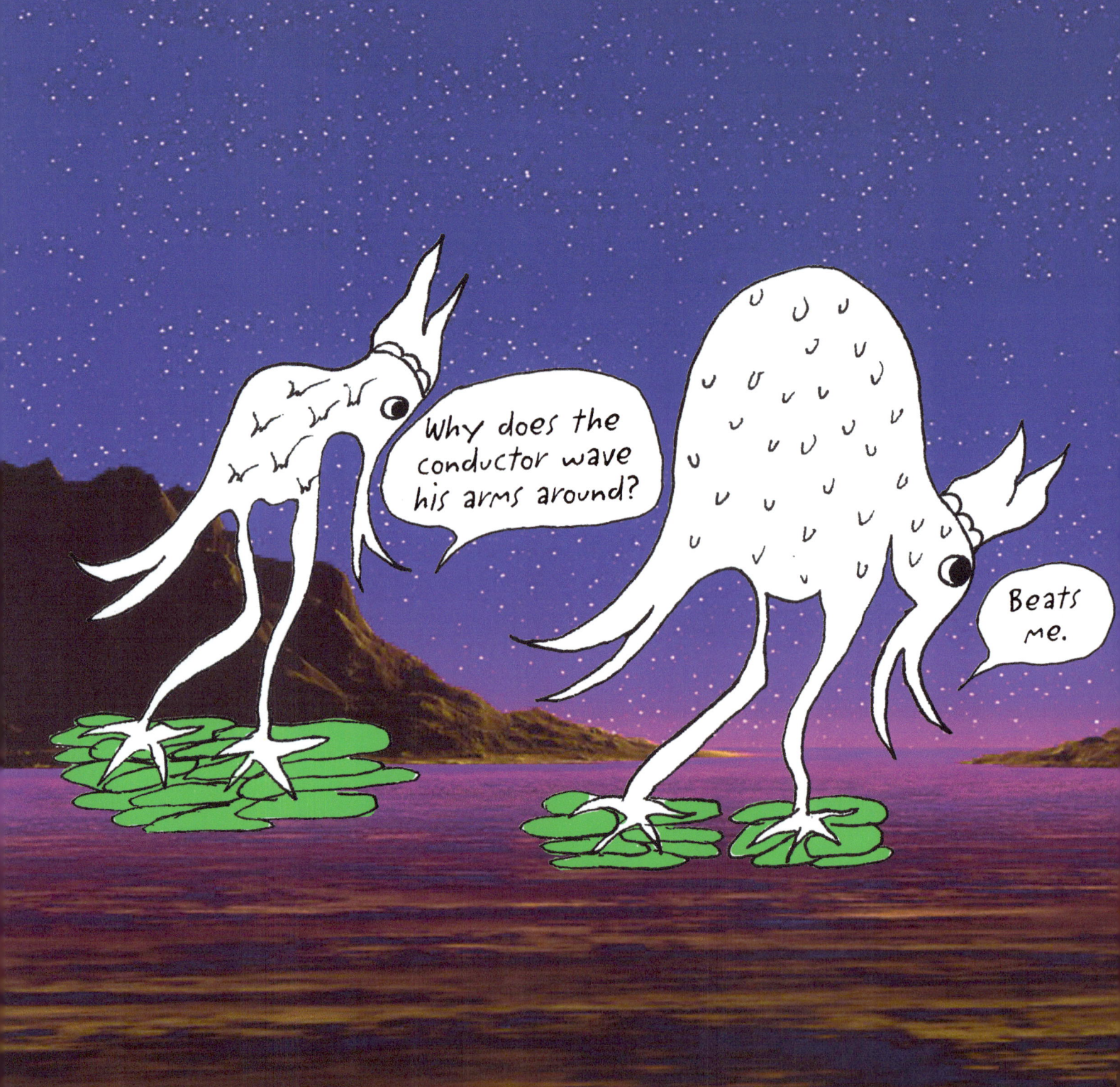

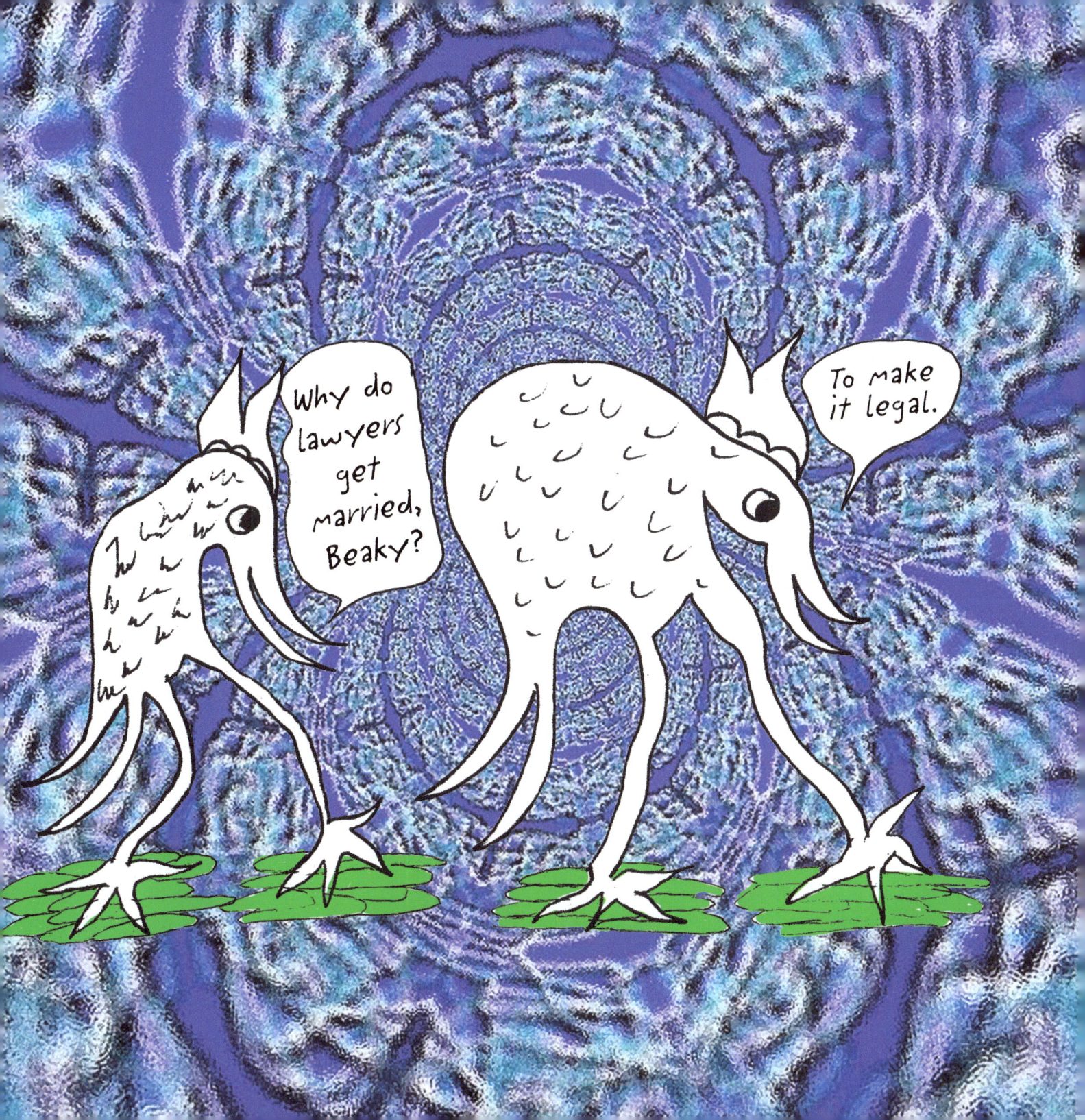

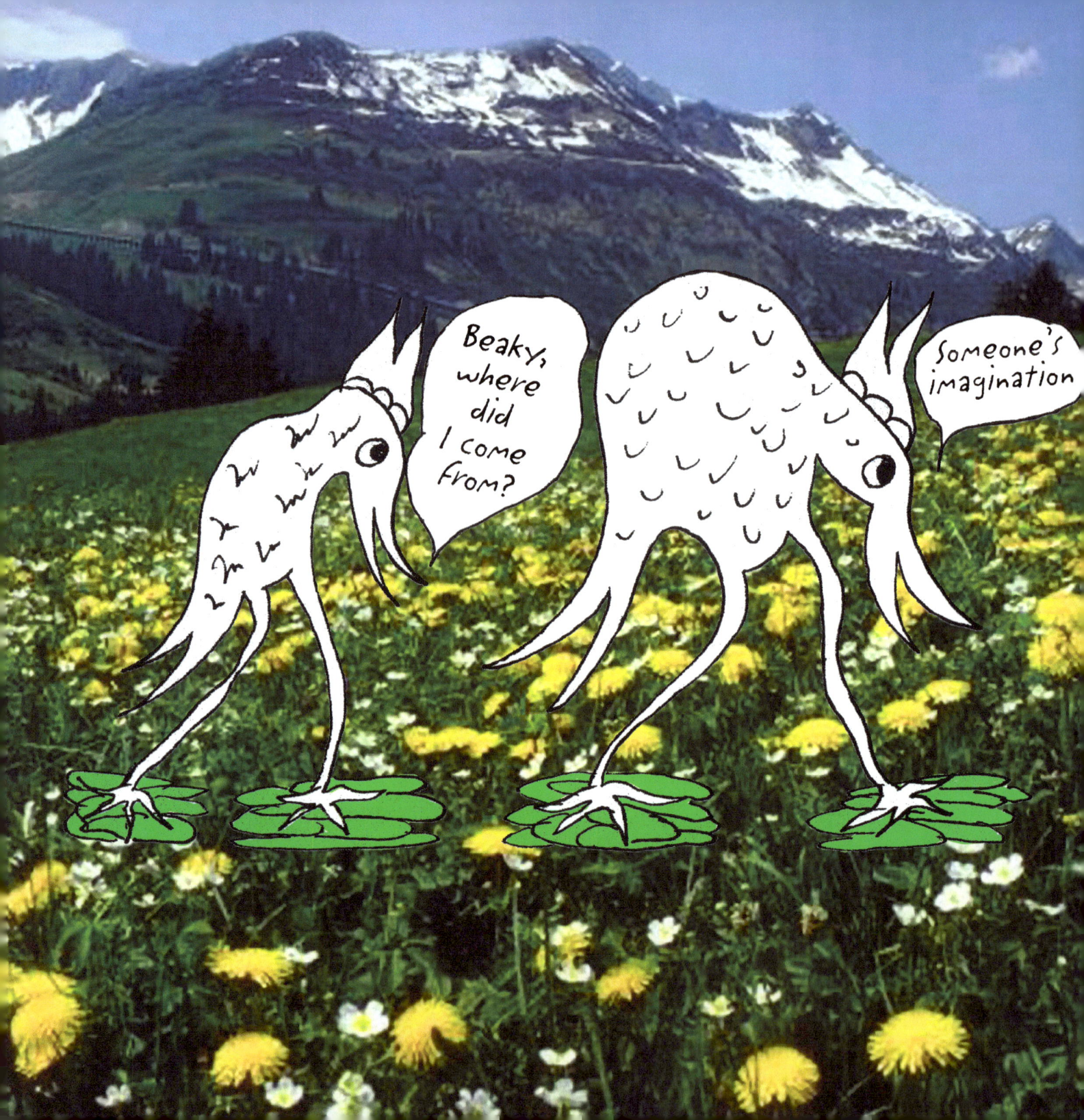

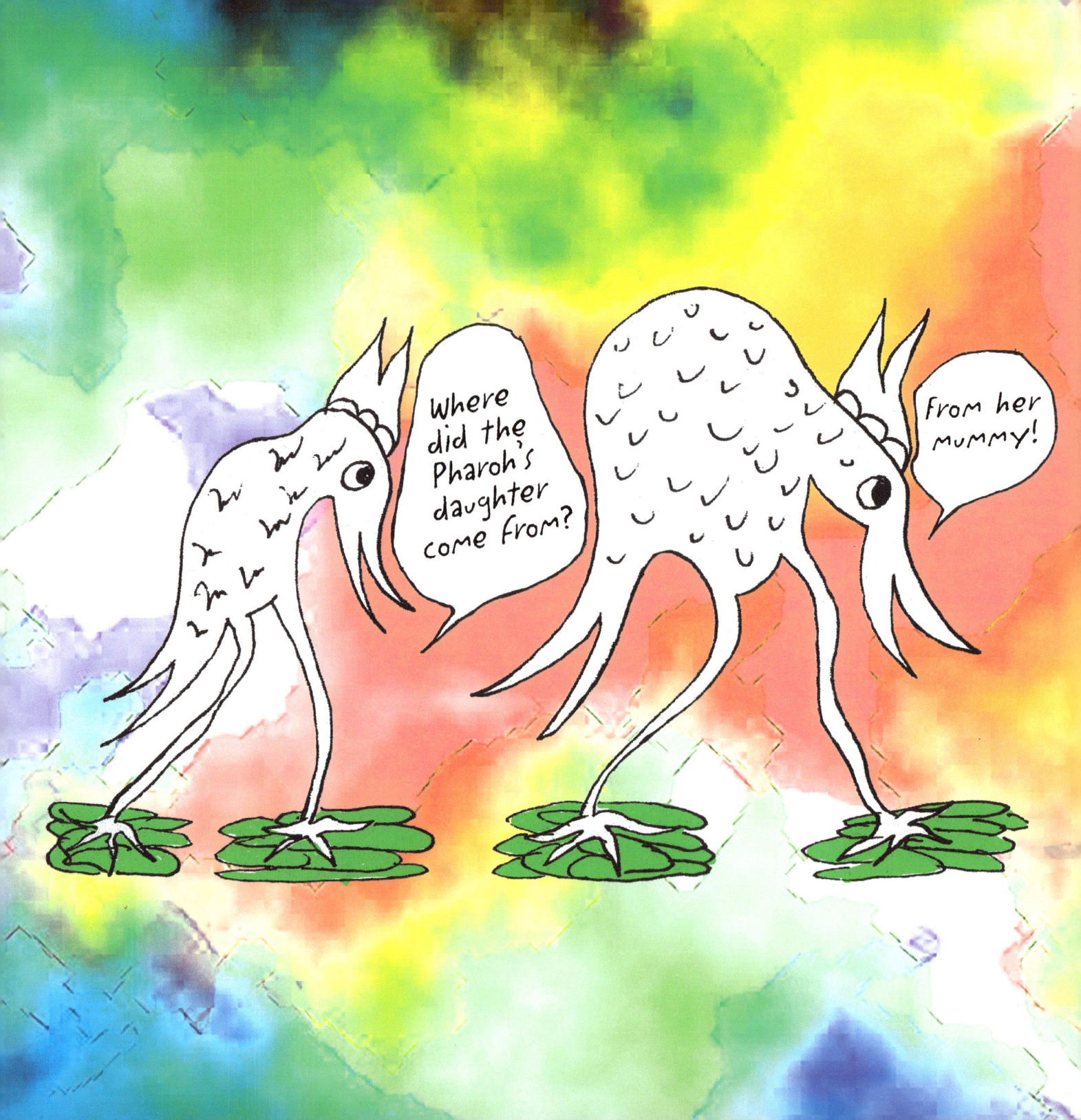

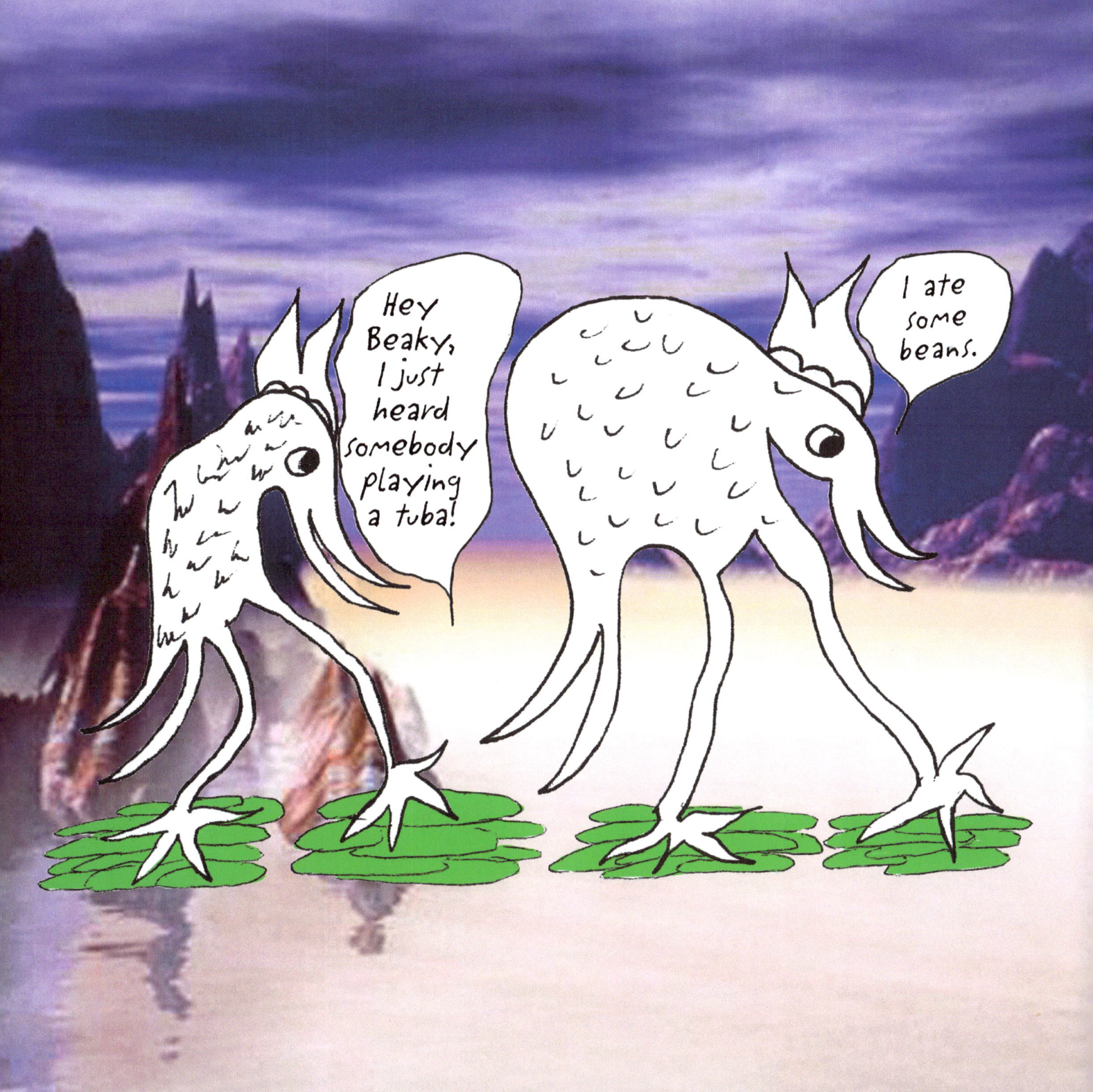

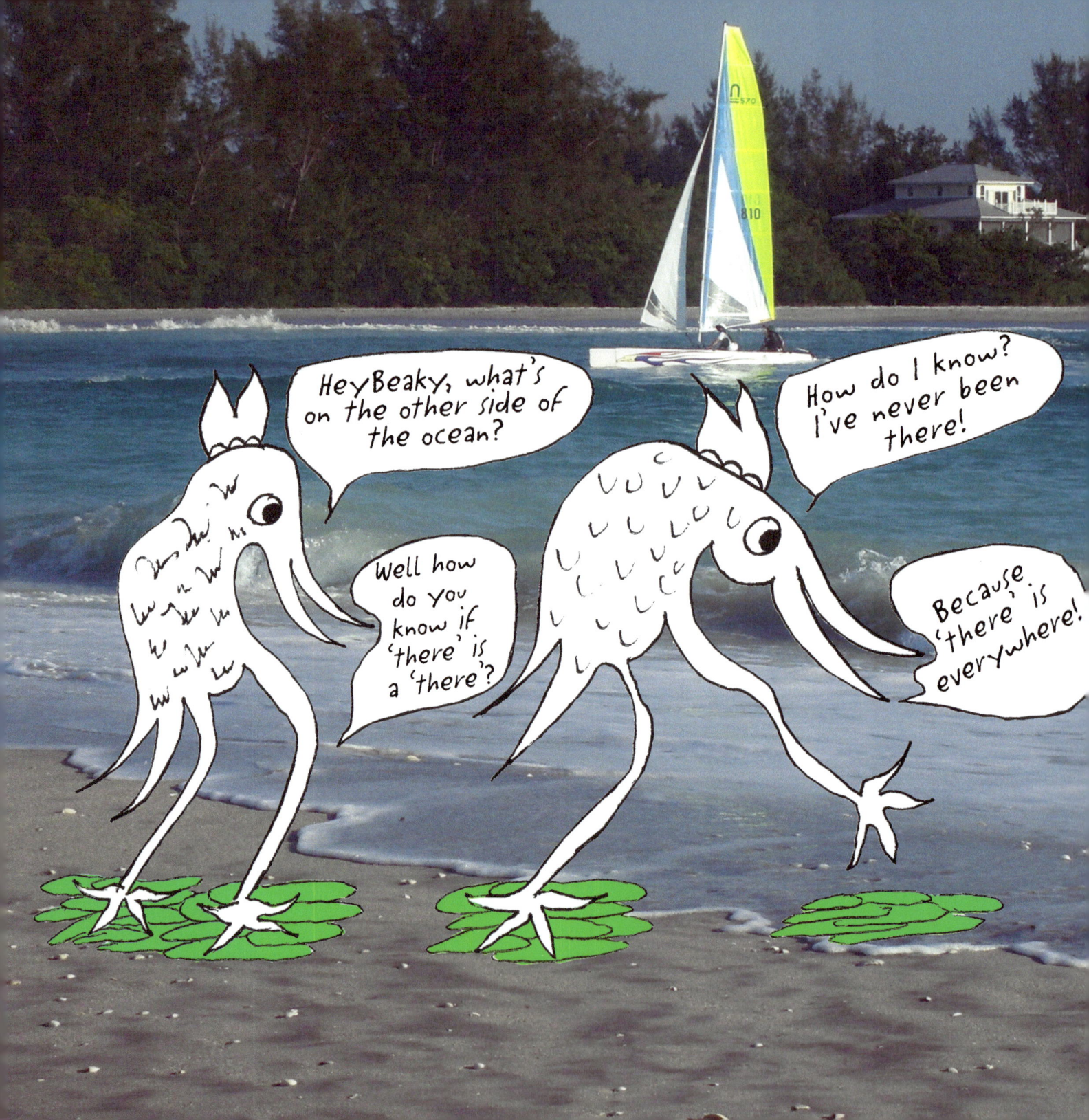

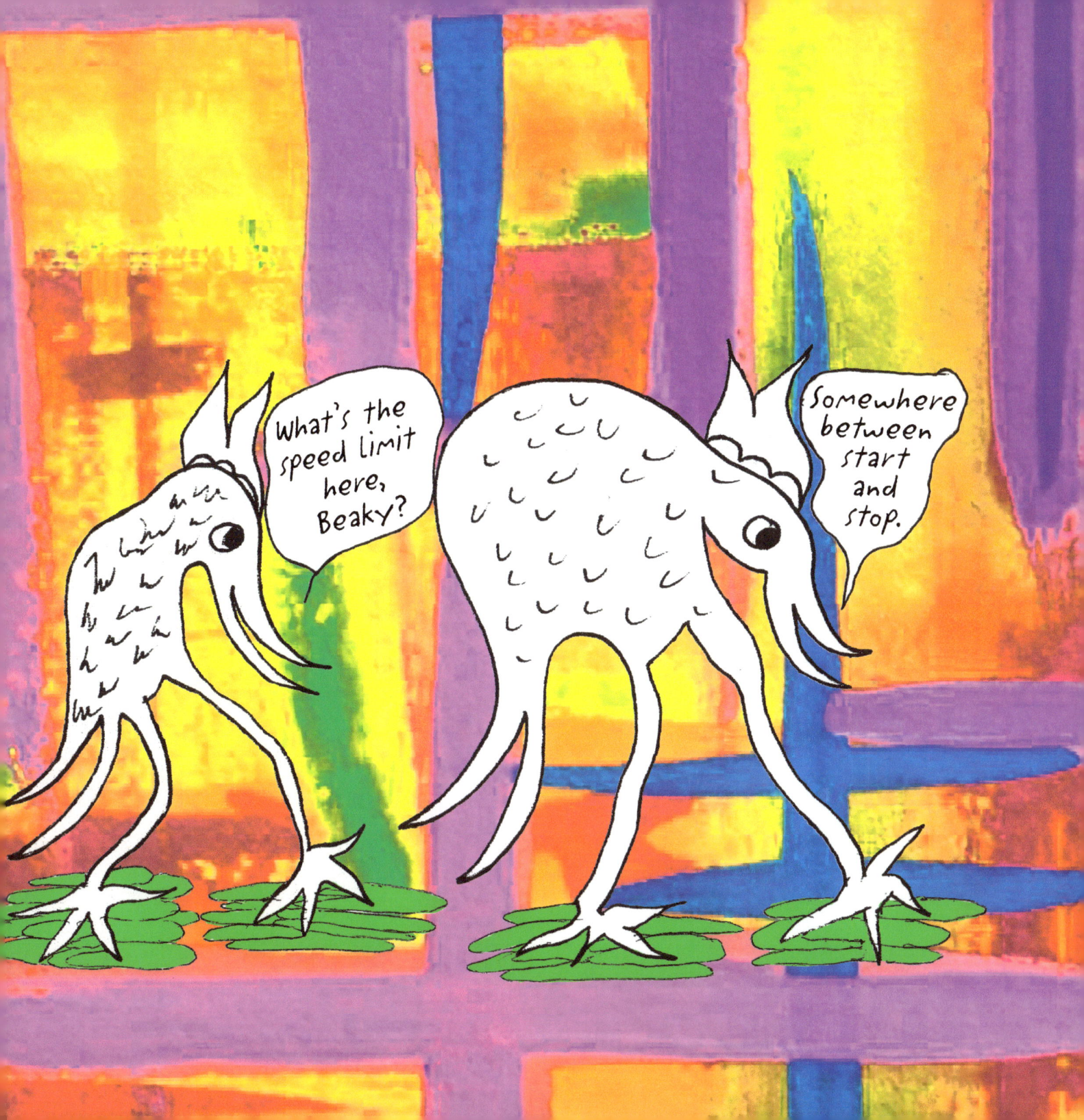

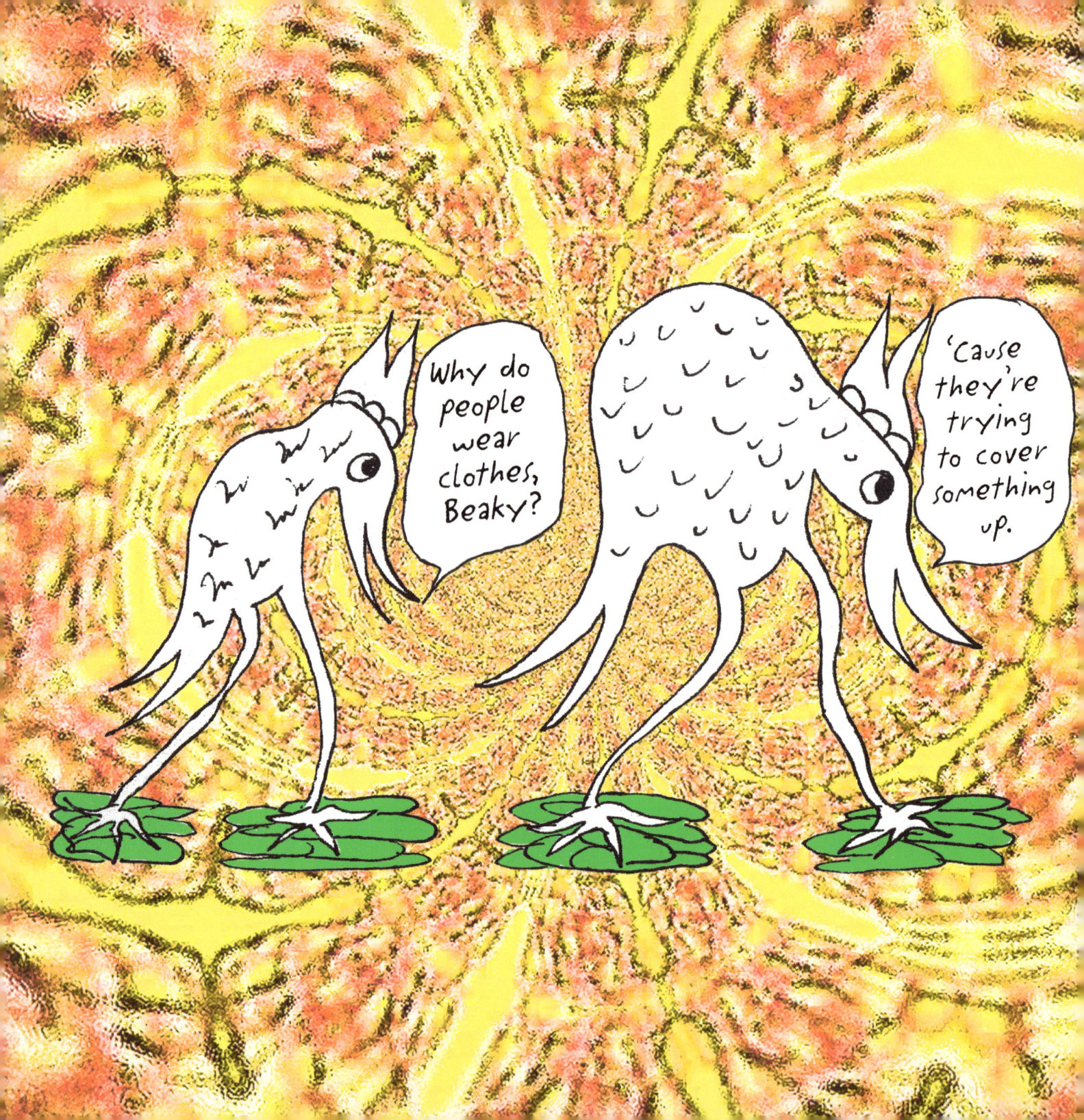

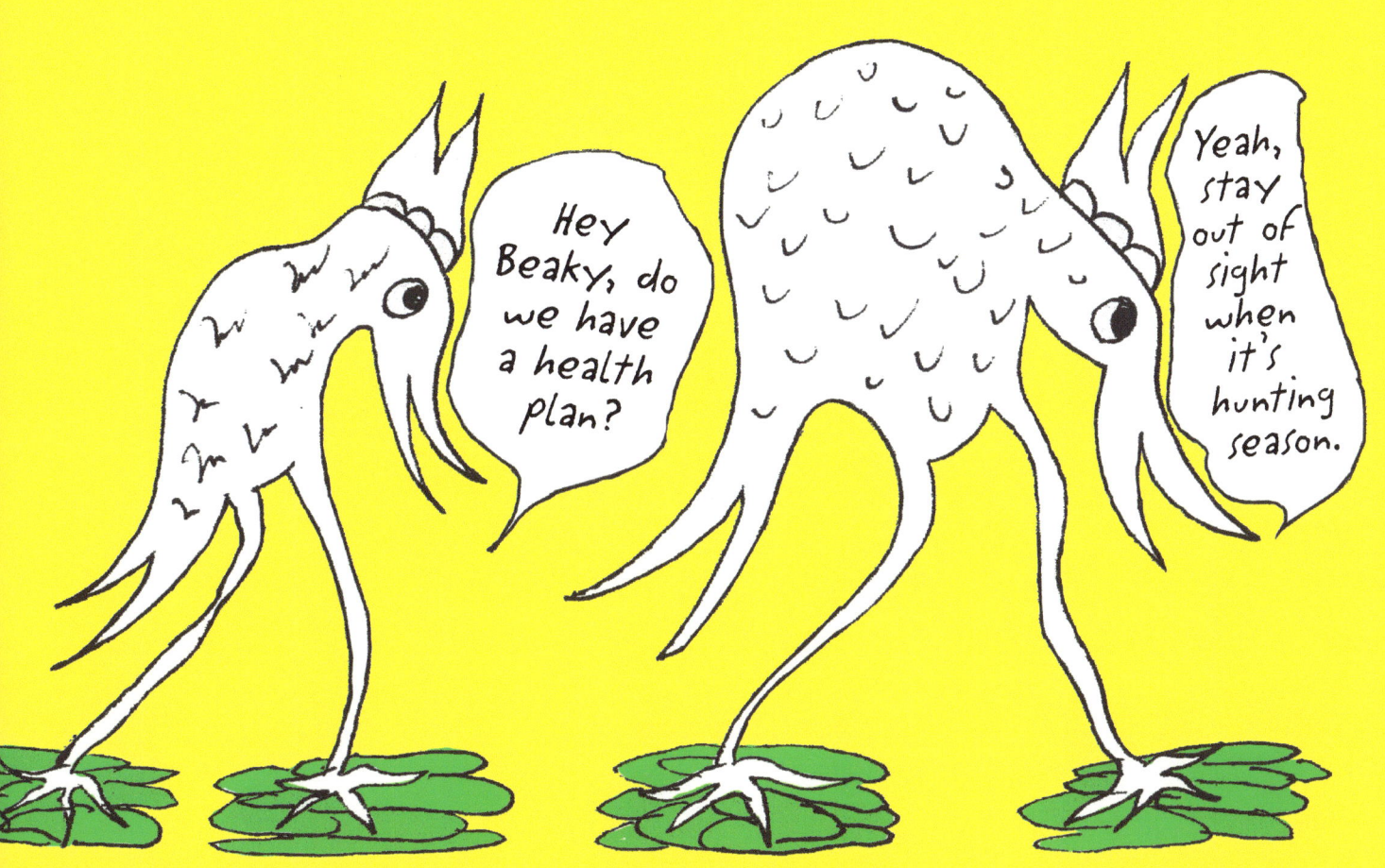

www.ingramcontent.com/pod-product-compliance
Lightning Source LLC
Chambersburg PA
CBHW041311180526
45172CB00003B/1057